ABANDONED PENNSYLVANIA

REMAINS OF THE KEYSTONE STATE

JENN BROWN

AMERICA
THROUGH TIME®
ADDING COLOR TO AMERICAN HISTORY

America Through Time is an imprint of Fonthill Media LLC
www.through-time.com
office@through-time.com

Published by Arcadia Publishing by arrangement with Fonthill Media LLC
For all general information, please contact Arcadia Publishing:
Telephone: 843-853-2070
Fax: 843-853-0044
E-mail: sales@arcadiapublishing.com
For customer service and orders:
Toll-Free 1-888-313-2665

www.arcadiapublishing.com

First published 2021

Copyright © Jenn Brown 2021

ISBN 978-1-63499-322-7

Typeset in Trade Gothic 10pt on 15pt
Printed and bound in England

CONTENTS

ABOUT THE AUTHOR

JENN BROWN is a self-trained, hobby photographer on Long Island, New York. Her photographic work centers around vacant areas and buildings of historic character. Growing up in a household of trade workers, Jenn was inculcated to a world where craftsmanship reigned supreme. Jenn's early interactions with skilled labor influenced her to art and her later career choice in textile work. Her long interest in the ornate architecture that dominated the twentieth-century American landscape was a result and would add to what she refers to as "an addiction to abandonments." The constant search, thrill, and capturing of these structures has given her purpose.

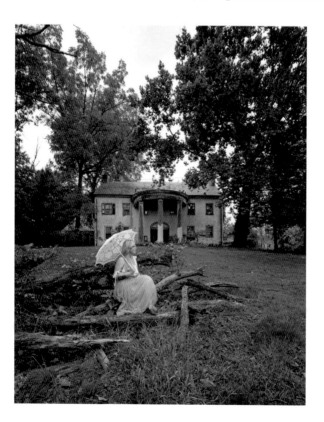

INTRODUCTION

Since the age of four, I've had a curiosity about the abandoned houses that were in my small hometown on Long Island. After encountering one down the road from my babysitter's house, I wondered constantly what was behind its closed doors. At the time, I was a young child with a fear of the unknown. The closest I ever got to the house was a set of stairs leading from the outside to the basement. A diary had caught my eye, and I carried it home and wrote in it over the years.

Growing up in a middle-class family meant vacations were always close by and usually in Pennsylvania, but I always loved to travel. It was my wanderlust combined with an interest in my family's history in ironwork and cabinetmaking that fueled my journeys out of New York. My explorations began in Pennsylvania in the fall of 2016. It was my first time leaving the state with no one by my side. Little did I know that trip would forever bring change over the years. Since I was young, I've always steered away from doing things alone and limited myself due to anxiety and that long-held fear of the unknown.

Abandonments have shaped me into the person I always hoped I could be. The constant research, traveling, and venturing out of my comfort zone have created such a drive. It changed my life, and it has changed the lives of others. Maybe I find myself drawn to the beauty of these manmade structures whose creators thought they would withstand the test of time. Or maybe it's finally being comfortable with complete silence. Perhaps it's the people I've met along the way, who also shaped me into the artist I've become.

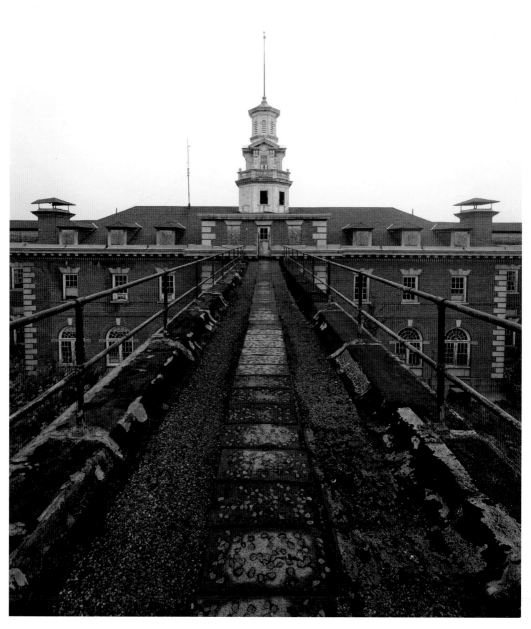

The former Allentown State Hospital in the early morning fog.

1

ABANDONED PENNSYLVANIA: REMAINS OF THE KEYSTONE STATE

Pennsylvania, as one of the states settled early by Europeans, has seen cycles of growth and decline for many centuries. The state obtained the nickname "The Keystone State" because of its location in the middle of the original thirteen colonies, and it has held a key position in the economic, social, and political development of the United States. In 1664, the British defeated the Dutch, taking control of the area. In 1681, a large area of land was given to William Penn by King Charles II of England. William named the land after his family, "Penn," and with the Latin word for forest, *silva*, after the vast forests that covered the area. The majority of the state is still covered in forests, which takes you back to an older time. The coal industry fueled prosperity in many areas of the state into the twentieth century. Now, small mining towns sit largely vacant and sadly run-down. The coal dust leaves the air heavy and hard to breathe, but it doesn't affect the townspeople. You'll see them around town, saying hello and catching up in the gas station with their morning coffee, their hands darkened by coal dust.

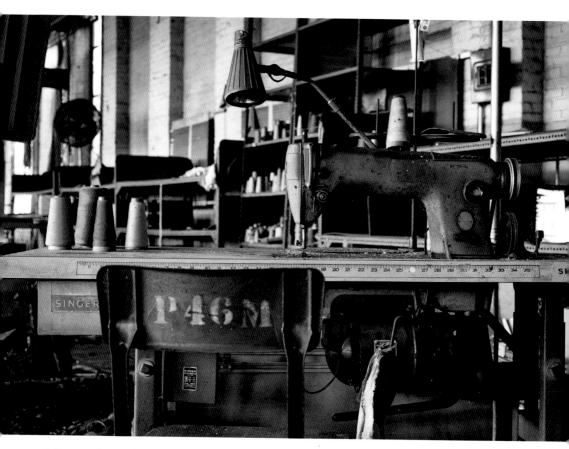

A Singer sewing machine, ready to be threaded.

2

SILK MILL

The Mining Town Silk Mill" once employed 800-1,000 people. The factory was forced to close in 1988 when cheaper labor become available to the south. Before coming to this area, one that is stuck in the past, we would never have imagined that coal towns still existed. We drove through town after town, seeing the decline and the hardship of living in these former coal towns. Even with so much sorrow, people were surprisingly a lot friendlier here than I was used to in New York. Everyone seemed to know each other, and they were welcoming to strangers.

It took three attempts to come through the time machine and the decades of abandonment. On my second trip, an older lady approached me as I walked toward a building with a camera in my hand. She firmly asked me not to photograph the place because her daughter now owned it. Talking to Hilary for over an hour, I learned how her daughter had purchased the building—because she could not stand to see another of the town's oldest buildings demolished. She has high hopes of one day restoring the property, but she's still not sure as what. The family has been asking members of the community what they would like to see done to the building. One townsman requested an indoor go-kart track. We talked endlessly about the history, the original owner, and artifacts that were no longer there. Hilary told me about an art installation that she had done, drawing pictures of the workers on the exterior of the building. Excited to be conversing with another artist, she ran into the house to find the drawings.

Hillary is one of the nicest people you will ever meet. While inside gathering her drawings, she grabbed a popsicle to cool me off in the summer heat. If that wasn't kind enough, she insisted that before I made the long trip home, I have a meal and drink on her at a once a favorite hangout spot, when she was a teen. She wouldn't take no for an answer.

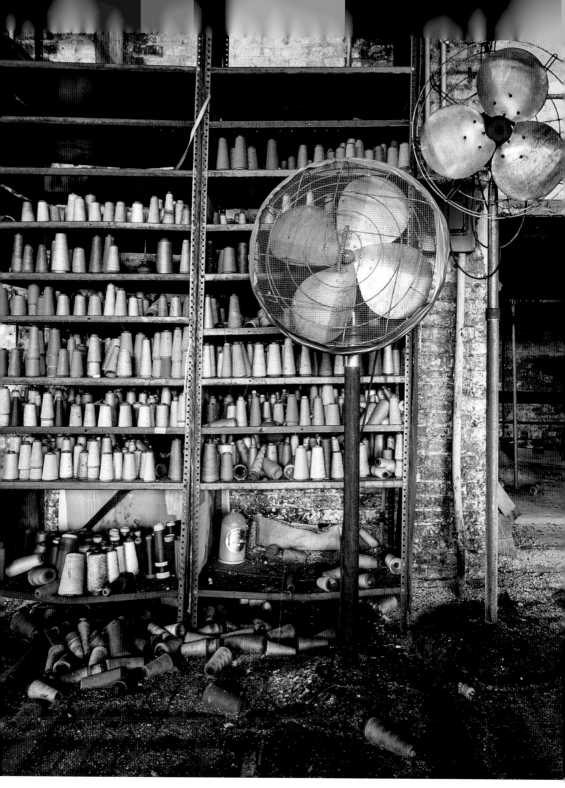

The rainbow wall of thread and industrial fans.

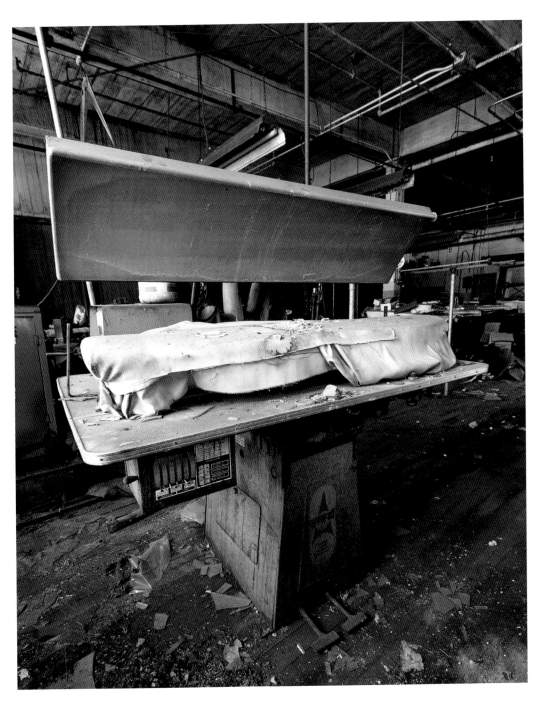

Industrial clothing press.

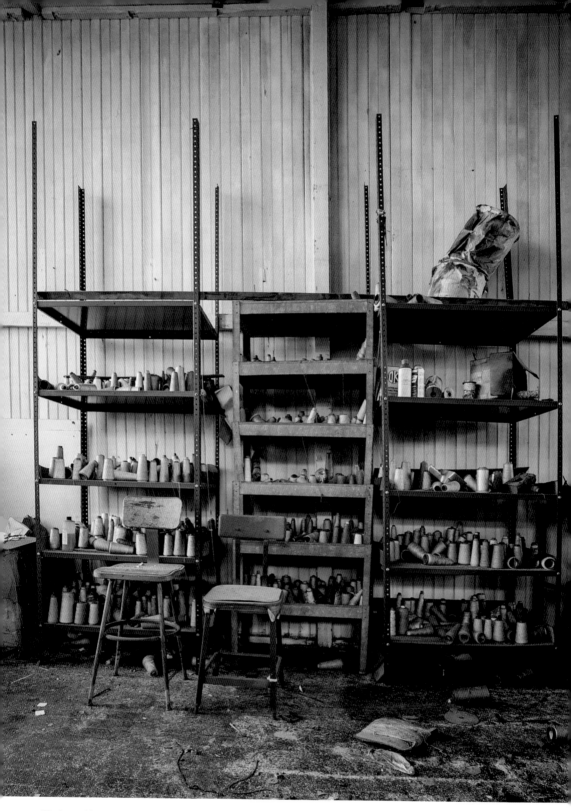

Neglected for decades, this building and its walls have started to slope. The current owner has erected beams inside the brick structure to prevent the entire room from collapsing.

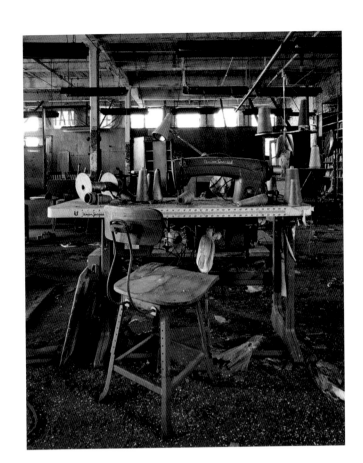

Right: The sewing machine awaits a worker's return.

Below: Cobwebs cling onto spools of colorful thread.

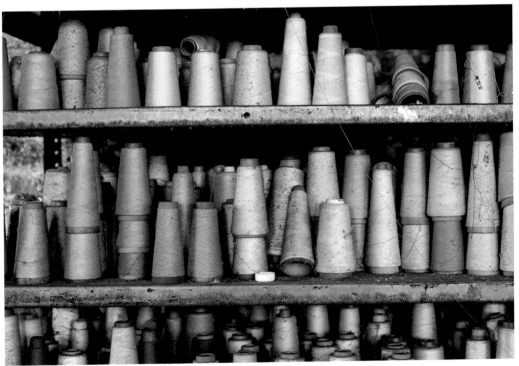

3

PLACES OF WORSHIP

W illiam Penn and the Quakers found refuge from religious persecution in the new colony, and Penn wanted it to be a place of religious freedom. Pennsylvania is home to many places of worship in its major cities. But over generations, as the number of people who practice religion or who are faithful have declined, these once magnificent structures and their handcrafted details have slowly rotted away.

The Christ Memorial Reformed Episcopal Church was built in 1887. During a thunderstorm in 2004, the 171-foot stone steeple was struck by lightning, causing the spire to crash through a section of the church. Lacking funds for the costly repairs, the church was sold to a local developer after a two-year legal battle. The roof underwent extensive repairs, including structural stabilization with a partial demolition, in 2014. Even with this turmoil, the women's shelter continued operation and limited prayer services were held in the chapel, although the rest of the church remained vacant. In 2019, the historic church was demolished.

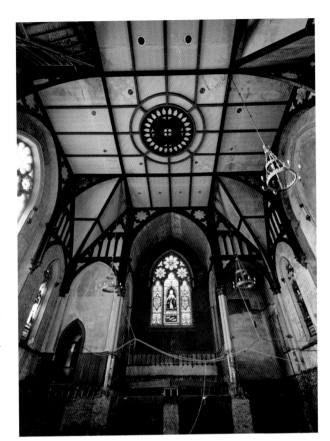

Right: From the basement of the church, you can see that the church was once being restored. The pews and floorboards have been removed. To access the once pulpit, a ladder must be climbed.

Below: A small-town Sunday school and community center sits on a hilltop as life continues on around it.

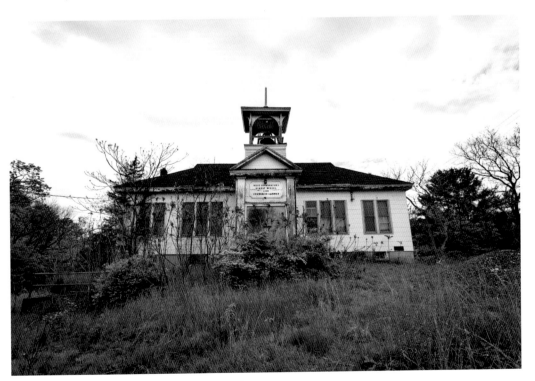

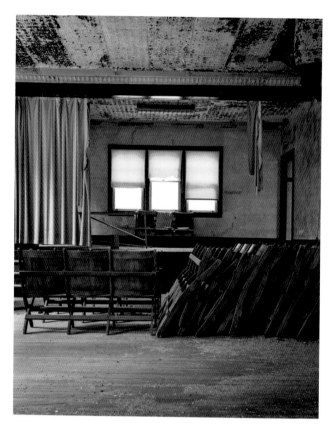

Left: The stage curtains still hang, and chairs have been stacked for storage.

Below: Left-behind hymnals and encyclopedias.

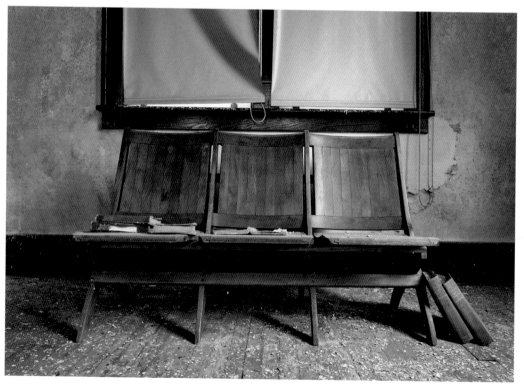

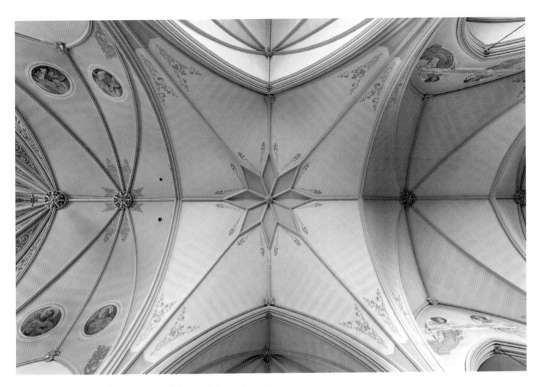

It's worth getting a sore neck to see this ornate ceiling.

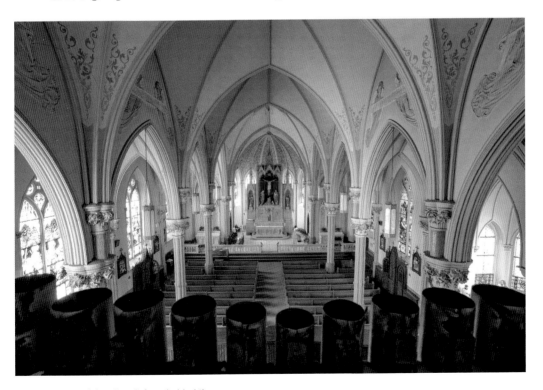

A view of the church from behind the organ.

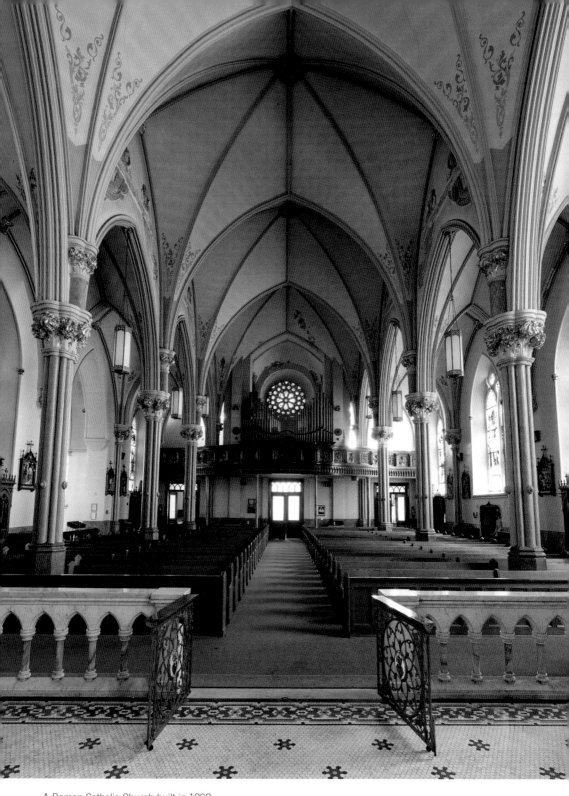

A Roman Catholic Church built in 1898.

Right: Celebrating the Holy Spirit.

Below left: A former Methodist church built in the late 1800s.

Below right: The church closed its doors in 2004 because of poor structural integrity. It is now home to drug addicts and homeless. In one main-level room, heroin bags lie scattered on a table and the floor. The stairs leading to the balcony are covered in feces. And the small rooms off the hallway are home to those with nowhere else to go.

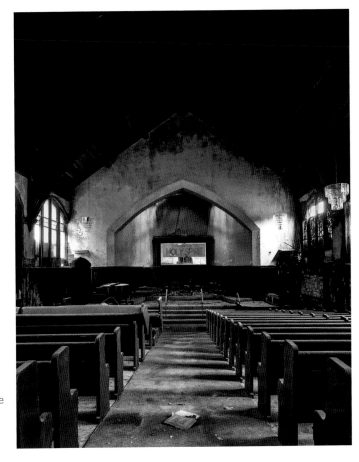

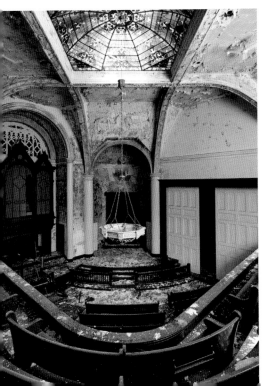

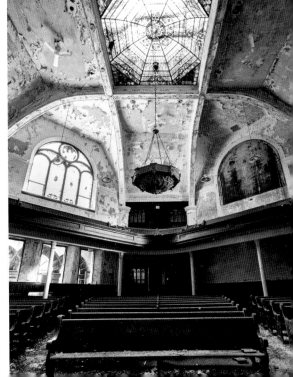

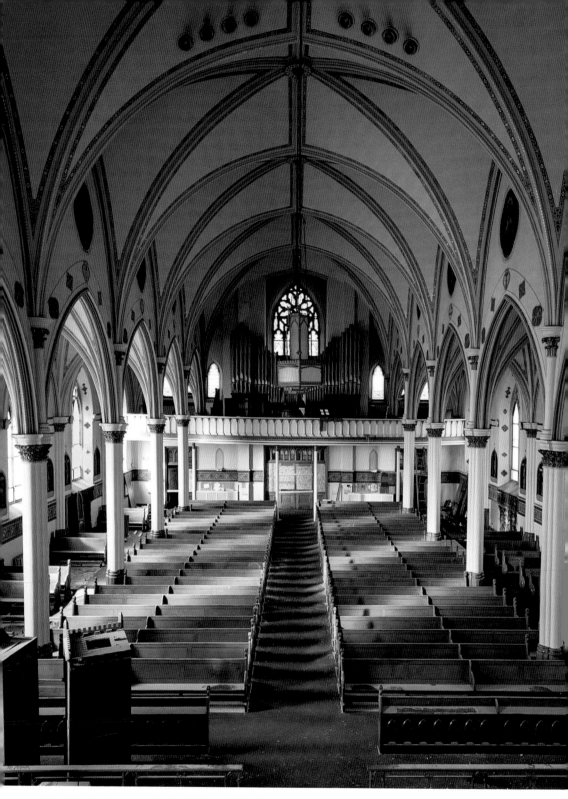

This Catholic church was built in 1895. In 2013, the congregation merged with a nearby church because of dwindling attendance. The church is relatively in good condition, but its Gothic-style architecture will once be lost to Mother Nature.

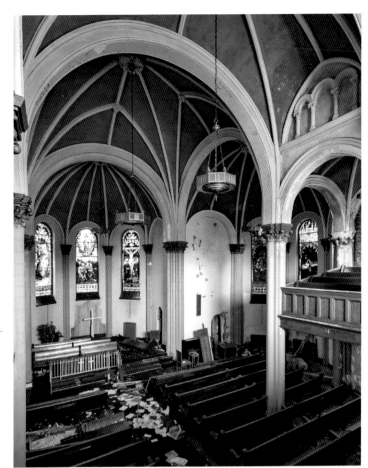

Right: This church, messy but no longer decaying, began renovations in 2018.

Below left: A rural church, at a town crossroads. The cemetery across the street dates to 1908.

Below right: "Free Will Church" with Tiffany stained glass.

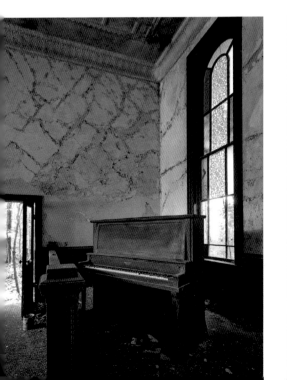

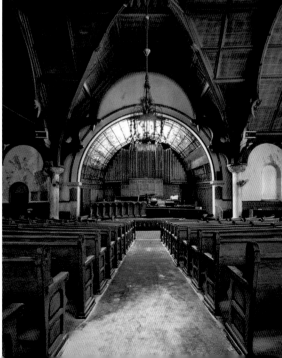

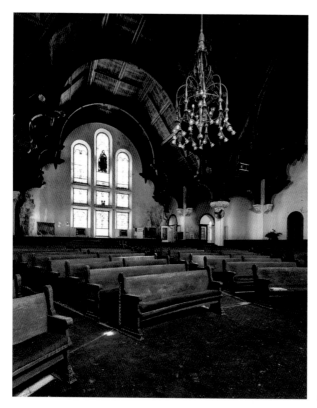

A Baptist church built in 1912.

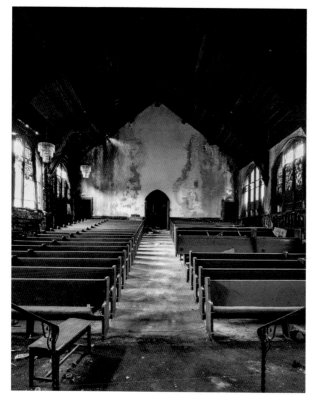

The "Mosquito Church," so nicknamed because of the water-damage-soaked floors and beams. From the constant moisture, the church becomes a breeding ground for blood thirsty insects. It's strange and fitting that the walls are tinged with red.

"The Majestic Temple" is unlike any other Shriners auditorium in the country and surprisingly cost only $230,000 to build. Between 1932 and 1970, the building was used for dances, parties, social events, and events for the Shriners and the community. In 1932, after a new auditorium had been constructed, the temple began a new era of entertaining the public, hosting weddings, graduations, concerts, and orchestra and theater performances. Sadly, the theater was forced to close once newer and better-equipped theaters entered the area by the late 1930s. In 2005, the building was purchased to preserve and revitalize the building. However, the 2008 financial crisis brought the restoration to a halt. In March 2019, the state senate allocated $100,000 to continue structural repairs and to restore the Moorish architecture. The Temple Restoration Project proposes to return the main auditorium to its original flat-floored configuration, creating a multiuse event space.

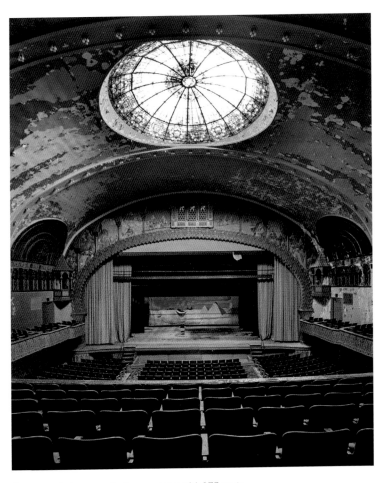

The upper balcony overlooks a vast sea of 1,375 seats.

 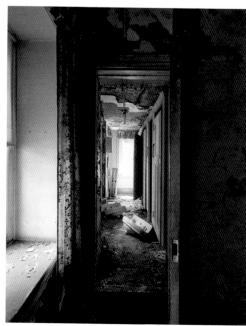

Above left: The temple's dressing room. A vacuum cleaner and fake plant remain in the room, along with temple gowns once used by the Shriners.

Above right: The bathrooms have sadly seen better days.

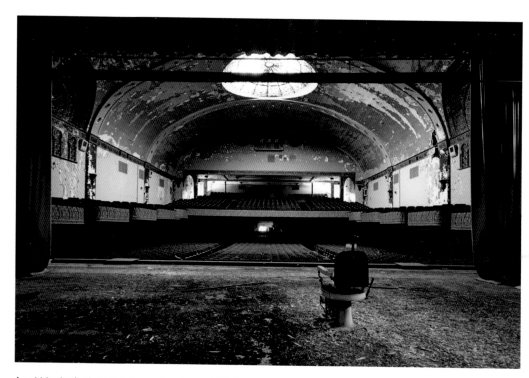

An old barber's chair remains on the stage, which is covered with pigeon droppings. The overpowering smell makes it difficult to photograph the theater from this angle.

On the third floor, in a closet at the top of a narrow spiral staircase, you will find this piano. The acoustics in this domed ballroom make you wonder what it was like in its heyday. The rooms surrounding the ballroom were used for prop storage, dressing rooms, and offices, some even with showers.

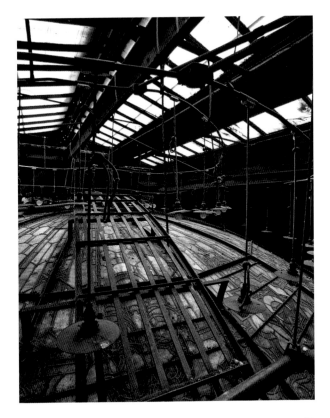

The catwalk on top of the domed stained glass. The light bulbs are still intact.

4

THEATERS

T his 2,040-seat Art Deco theater from 1927 was a major venue on the Chitlin'
Circuit from 1951 to 1978. The theater provided commercial and cultural
acceptance for African American musicians, comedians, and other entertain-
ers during the era of racial segregation. The lavish interior had high ceilings, stained
glass, and terracotta. The theater was originally built for wealthy patrons in the area.
Unfortunately, it opened on the eve of the Great Depression, which devastated the
neighborhood. By the late 1950s, the theater evolved into a mecca for live music,
which led to a new boom in the neighborhood. Eventually, with riots, drug use,
and violence rampant during the period of urban decay, performances stopped in
1972. African American artists were also now able to play in larger, mainstream
venues, and by 1978, the theater was closed. The building reopened as a church
in the 1980s until a storm in 1991 damaged the roof and the gilded auditorium.

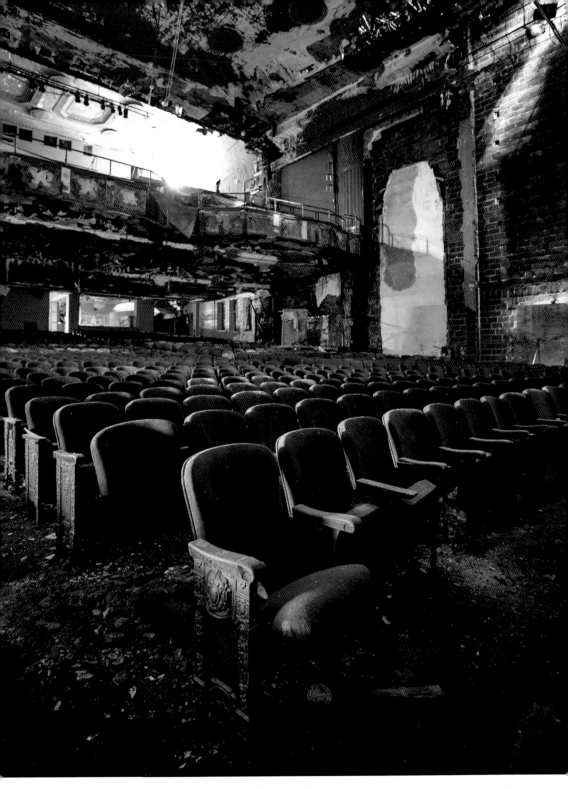

Light slants in through the upper balcony door. With the building in such disrepair, it is hard to believe that the construction lights can be turned on with a flip of the breaker.

This 1,894-seat movie palace opened on January 24, 1924. The theater operated until 1972 and later became a church. By 1992, the church had moved out of the building. In the late 2000s, the building was purchased, and renovations began. The current owner intends to bring the building back to life as a memorial for his late wife. Much of the building's interior was repainted in 2012 to match the original colors. The roof was repaired, electrical and plumbing work completed, and the building stabilized. The plans are for the theater to host live performances and house a restaurant. Since I photographed this structure, vandals have sadly taken over, spray painting over the restorers' hard work.

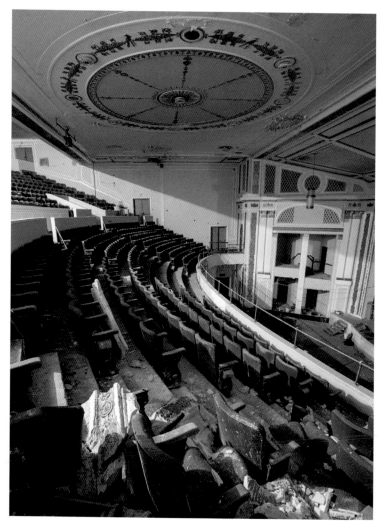

A mixture of old and new.

5

EDUCATION

T he Handcuffed High School" was constructed in 1912 for a student population of more than 5,500. There were originally two separate buildings, one for the boys and the other for the girls. Each school had its own auditorium, and the main gym had a boys' and girls' side. In September 2011, the school moved to a newer smaller building due to decline in enrollment. Its doors have been closed for only six years, so decay hasn't fully taken over the structure. In 2016, renovations began to convert the buildings to apartments.

On my first trip visiting what has become one of my favorite locations, we parked the car and walked a bit down the road. An open gate caught my eye, and we made our way down into the stairwell. To our surprise the door was open! We entered the stairwell and wandered around the hallways and stumbled upon the auditorium. I couldn't believe that something so beautifully crafted could be sitting here, left to rot. Once we finished photographing, we made our way through the school, taking hallway by hallway. We located the gym, which had a plaque on each side—Boys and Girls. As we got deeper into the school, we noticed lights in the distance. Keeping a close eye on our surroundings, we discovered the school was under construction. As a group, we decided it was best to make our way out. As we did, we heard someone above us, talking in the stairwell. We froze, and once we heard the worker's footsteps moving closer, we got out as fast as we could.

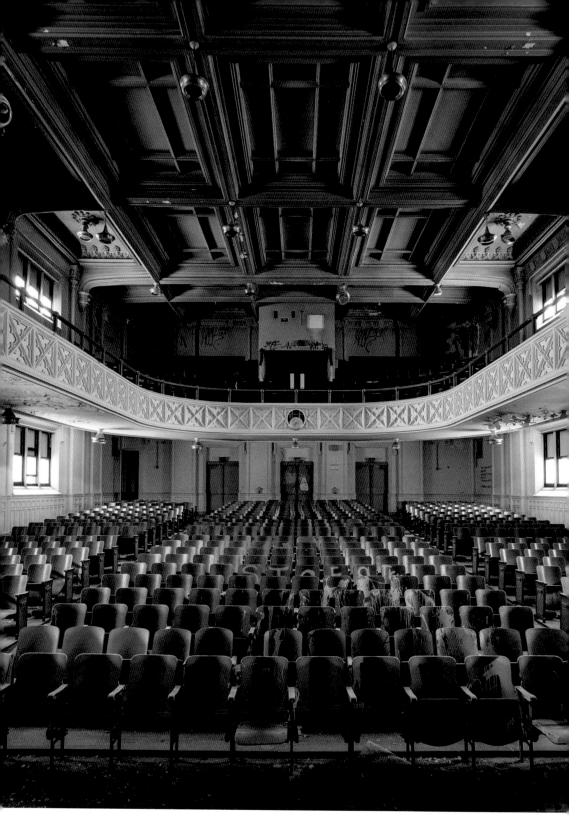

The ornate boys' auditorium.

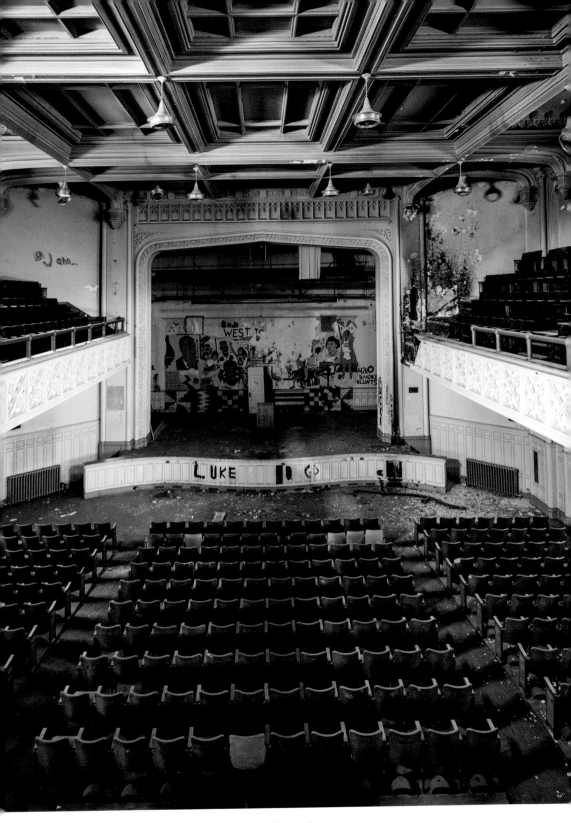

A mural with Martin Luther King, Jr. slowly peels off the wall.

Because the thrill wasn't enough the first time, I decided I needed to revisit with another group of friends. Knowing that the school now had motion sensors, we carefully made our way in through a narrow entrance point in plain sight. We headed down the hallway, up the stairs, and following the construction lights, we came across a small dark gym. This gym had an upper track along the whole perimeter of the room. From there we continued our way into the auditorium, managing not to set off any sensors. We made our way around the boys' side of the school, and we couldn't believe our eyes—there was another auditorium. I fell in love with the white ceiling and green, wooden seats. I wondered how I could not have known about the second, even after the prior exploration and researching I had done. It's the only school that I've discovered with two. Shortly after that, another group of photographers was making its way into the school. A friend went down and took them to the boys' auditorium.

Time continued, and we ended up being inside for close to three hours. A friend and I left the girls' auditorium and tried finding our way back to the group. Taking the wrong turn, we ended up in nearly completed apartment rooms. We kept moving down the hallway, and up ahead, we saw the last group that had entered. Out of nowhere, the alarms started blasting. Luckily, we had just passed a stairwell leading to the outside, so we raced out of the school and over the wrought iron fence. The other group came out, gripping their cameras and tripods, handing them to me as they made their way onto the other side. Before we knew it, the police were on site, and we were searched, questioned, and left handcuffed in the back of a cop car for an hour. After the property manager finished his walk around the school, he chose not to press charges as we did not vandalize or use force to gain entry.

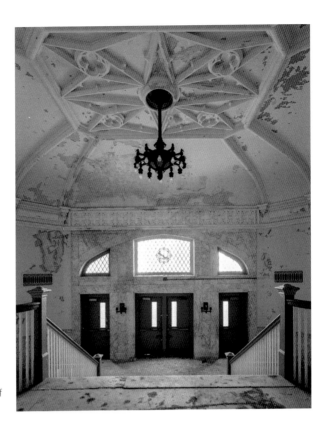

The main entrance to the boys' part of the school.

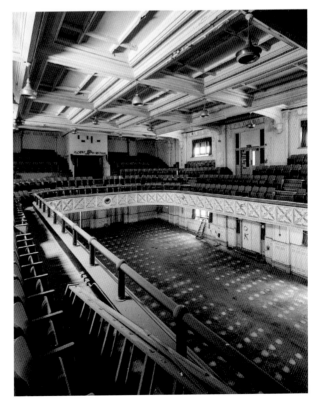

The girls' auditorium from the upper balcony. The main-level seats were removed prior to the renovations.

"Hope You Aren't Afraid of Heights School" was built in 1914. At the high school's peak, it held over 3,000 students. Enrollment declined as charter and magnet schools became available, and the school closed its doors in 2013. This school was always a must-stop on our list. Even after our run-in at the "Handcuff High School" and knowing there were also alarms in most parts of this building (especially the main level), we planned on making our way here. On the back side of the school, we found an open window on the third story. Thankfully we had brought a piece of chain-link fence to help climbing. I got to the second floor, but being only 5' 2", I was not able to reach the window ledge to pull myself up and through the window. My friend grabbed my wrists and pulled me up the side of the building. But the worst part was the way out. Two friends had to hold my arms to lower me back onto the fence against the wall. The most nerve-racking moment was when my feet were on the fence with nowhere to put my hands to make the climb down. Entering this school got easier with time, and I was able to capture it once again without risking my life.

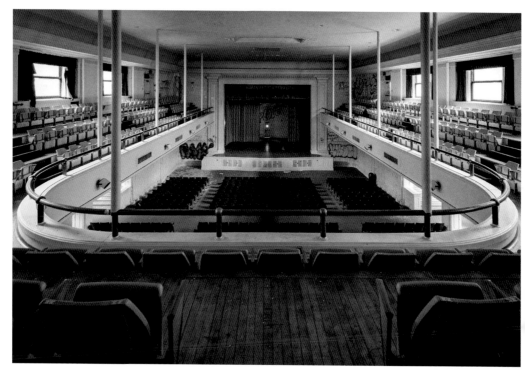

The back row of the auditorium.

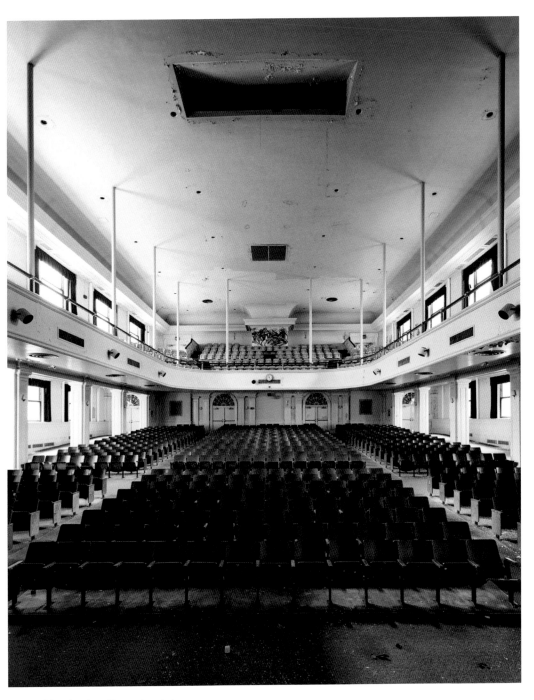

The view from the center of stage.

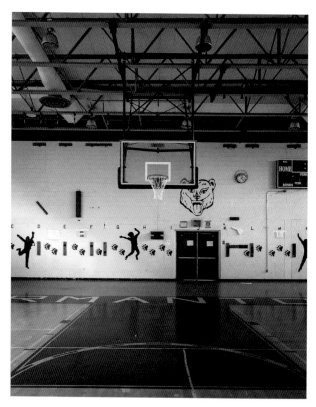

The gymnasium.

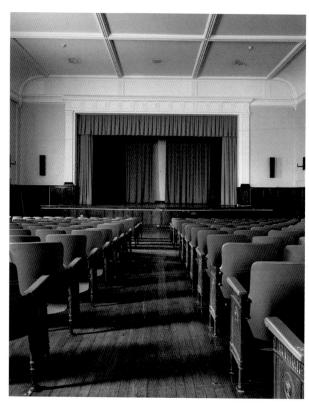

This 1927 late Gothic Revival high school closed its doors in 2013.

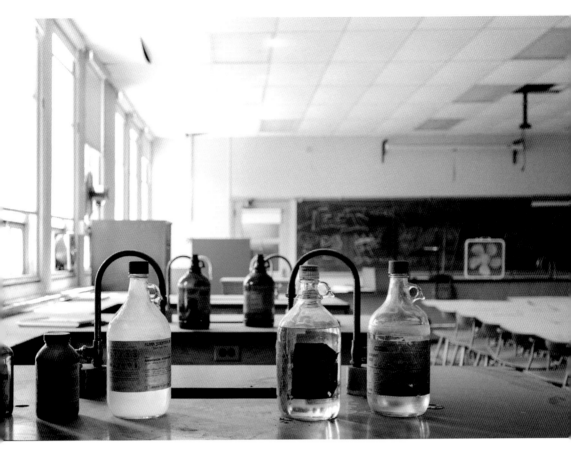
Experiments left behind in a rural school.

"The Red Curtain School" was constructed in 1926 as a junior high school. By 2005 the school district converted the coeducational school into an all-male middle and high school. The merger, which brought together youth from once rival schools, led to violence against students and teachers, which the chief operating officer described as "a transition problem." By 2011, because of budgetary issues and political feuding within the school district, the school was converted into a new high school. It operated as a comprehensive neighborhood school until 2013, when it was closed for good.

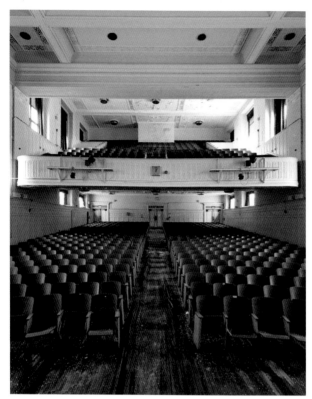

From 2013 until 2018, the school remained untouched and retained its charm. But since the winter of 2018, the school's auditorium has been vandalized by photographers and explorers. An Instagrammer has written his handle not only on the front of multiple seats but also on the walls, stage, and doors. While doing research for the book in 2019, I found the school covered with graffiti. It is always heartbreaking to see history being destroyed by people with no respect.

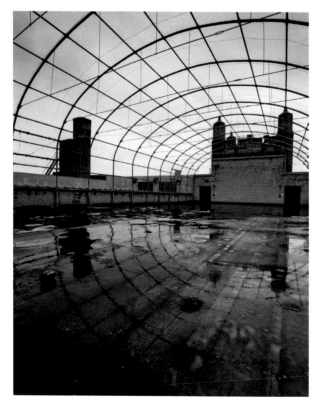

The rooftop basketball court, exposed to the rain and with poor drainage, becomes an ice skating in the winter.

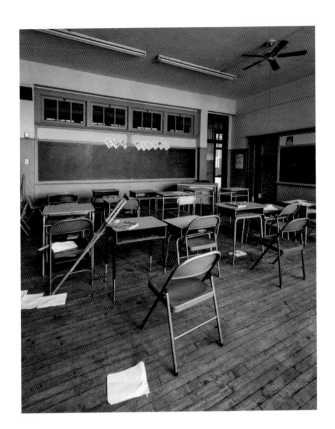

It's rare to come by classrooms with desks, books, and student assignments remaining. In many schools, halls and rooms are empty.

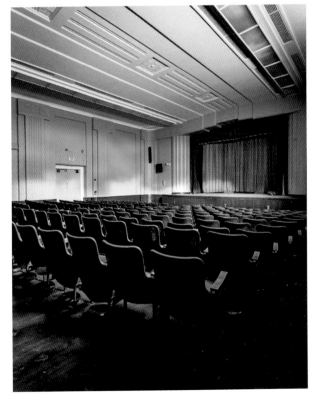

Built from 1935 to 1937, this elementary school closed in 2013.

6

STATE HOSPITALS

The medical surgical building at the State Lunatic Hospital was constructed in 1937 as a modern facility to replace the outdated infirmaries. The building was later converted to the State Hospital's Admission Building and was also used for outpatient clinics from the 1970s until the building was decommissioned in 2005. Medical equipment can still be found in rooms throughout the building.

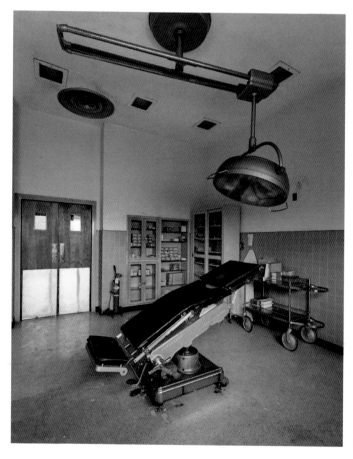

An operating room with medical supplies.

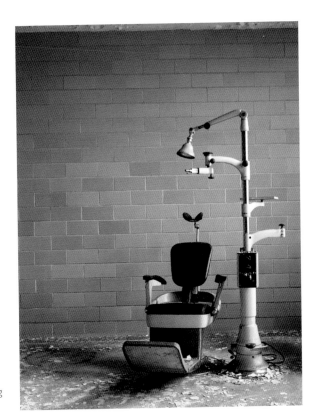

One of four optometrist chairs remaining in the building.

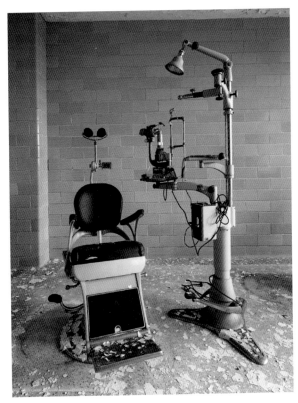

Another optometrist chair, with the examining equipment still attached.

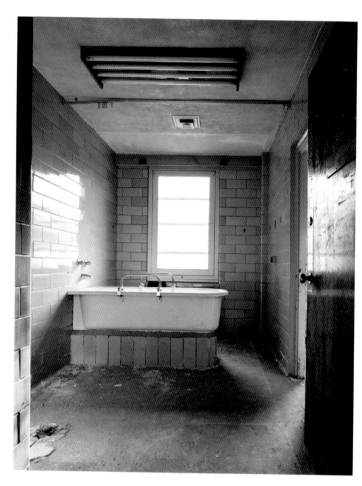

Left: A tub to bathe physically disabled patients.

Below left: An operating room that was later used as an office for admissions.

Below right: Medical supplies are scattered throughout the sterilization room.

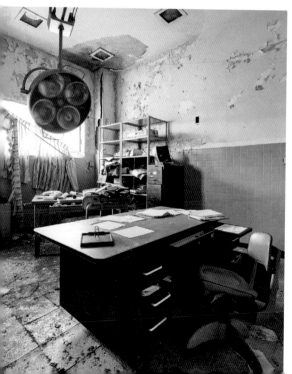

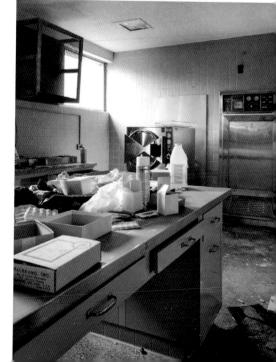

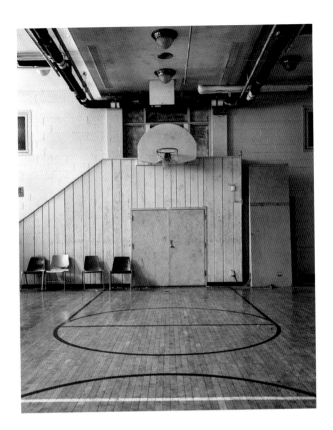

A state hospital's gymnasium.

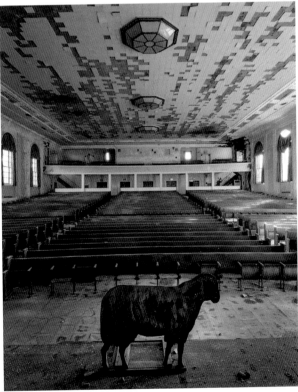

The theater in this women's
sanatorium has been decaying
since it closed in 1998.

7

PRISONS

This mountaintop sanatorium treated thousands of people diagnosed with tuberculosis from 1913 to 1964. Doctors prescribed fresh air, bright sunlight, and balanced nutrition in hopes of curing the illness. By the early 1960s, widespread vaccination and better treatment options had nearly eradicated the disease in the United States. The sanatorium was converted into a government-run mental hospital and operated until 1984. Four years later, after security modifications, the facility reopened as a medium-security prison for men. The 1,600-bed prison closed in 2013 to cut costs, and its inmates were transferred into a new prison, along with 900 inmates from another facility.

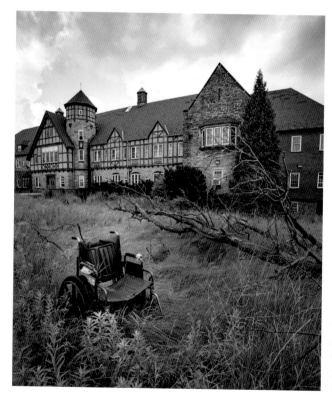

The exterior of one of the sanatorium's buildings. A few trees on the 326-acre property appear to have been struck by lightning.

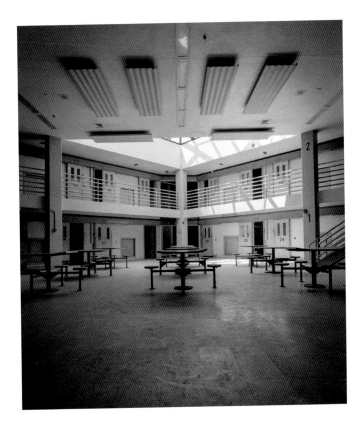

Ward number two.

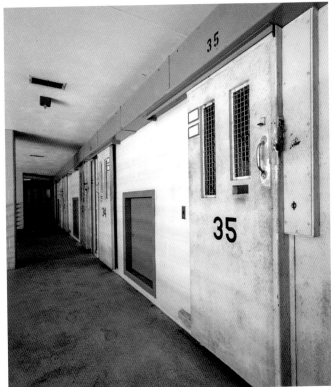

The upper cell block of ward one. Some cells in the wards remain locked. Others still have photos from pornographic magazines glued to the cabinets inside.

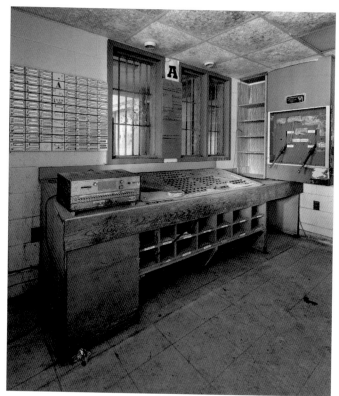

The control board that operates
the cell doors in Ward A.

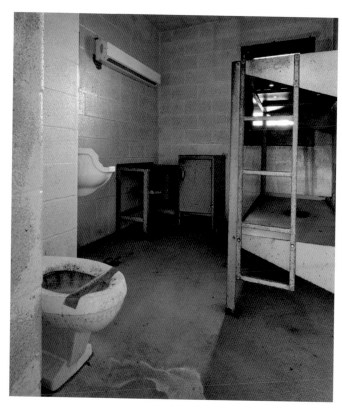

A cell inside Ward A.

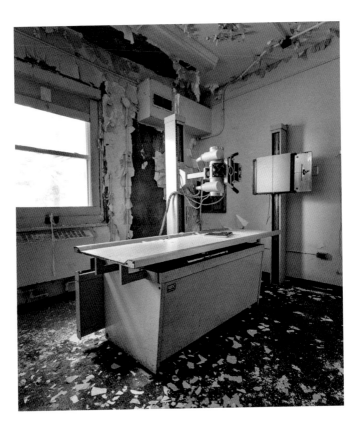

An X-ray machine in the
medical building.

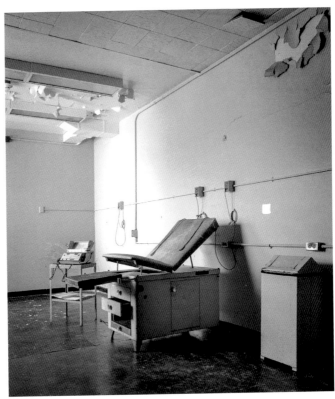

An examining room.

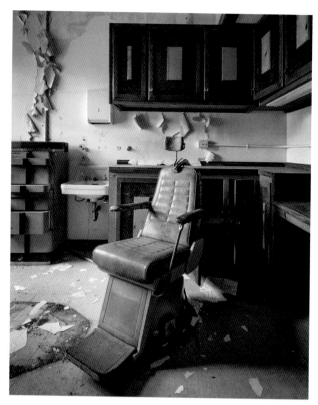

The dentist's office.

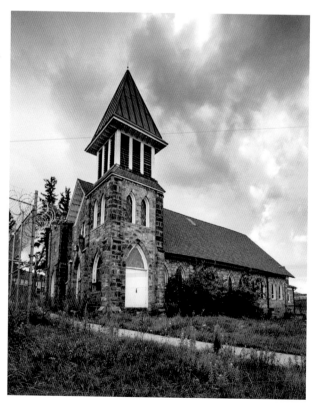

The prison's chapel.

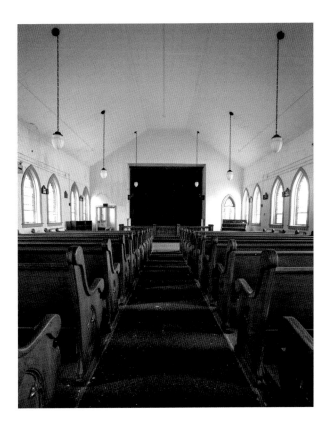

The interior of the chapel.

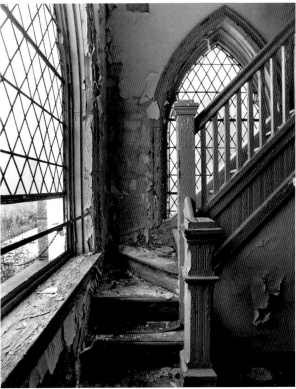

The chapel's crumbling staircase leads to a narrow balcony with two small organs.

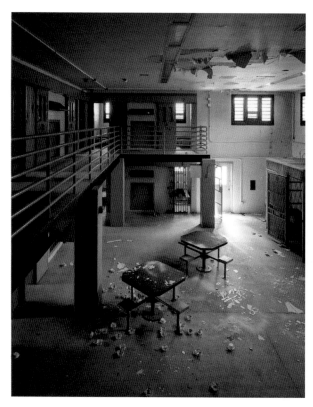

Open cereal packages left strewn on the floor of a cell block.

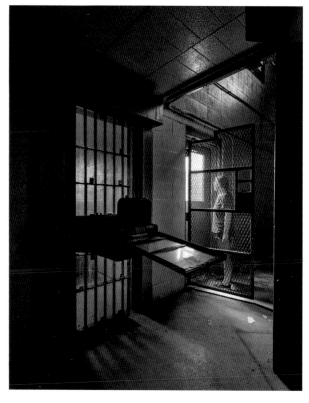

Self-portrait in the maximum-security ward. Two of the cells in this small ward housed dangerous men. Their meals were delivered through a slot in their cell door, to avoid any contact with the prisoners. This was the only cell with plexiglass covering the barred door.

B. F. Willis, known for designing Eastern State Penitentiary, constructed this castle-like county prison in 1906. The five-story, 30,000-square-foot red brick structure replaced the crowded original jail, built in the 1700s. The aging prison closed in 1979, when it was replaced by a new facility in a nearby town.

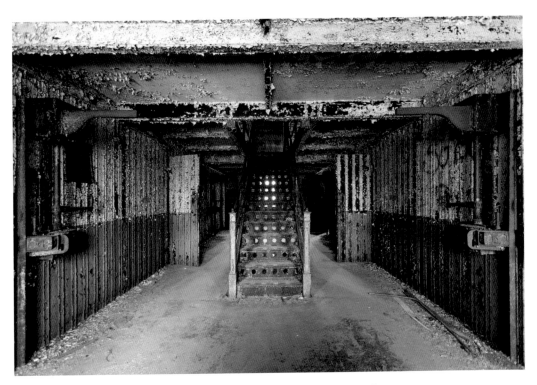

The central staircase of the prison, which houses four cell blocks on each floor.

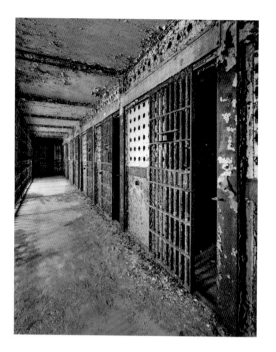

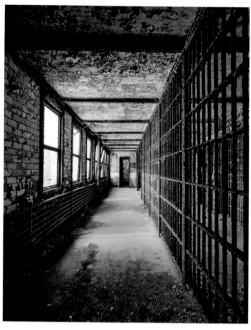

Above left: Inmate cells.

Above right: An officer's hallway, with a protective barrier.

Left: A better glimpse of the protected officer's hallway, looking into the inmate cells.

8

FUNERAL HOME

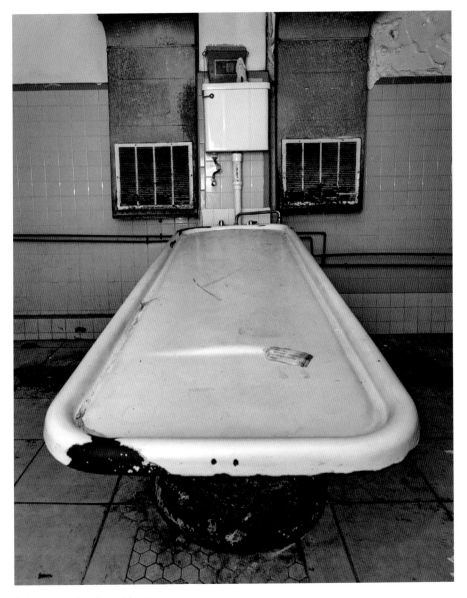

Autopsy room in a funeral home.

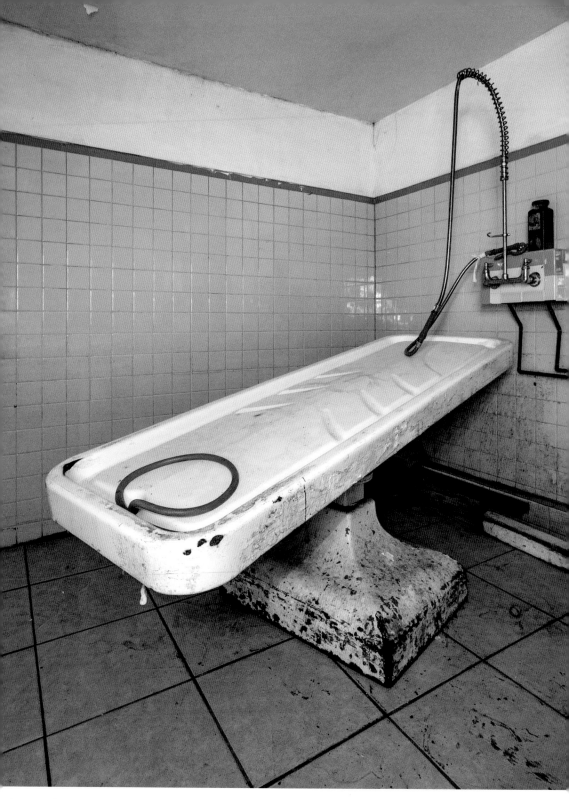

When the funeral home's owner died, his son struggled to pay the inheritance and estate taxes. The funeral home was seized by the government for nonpayment of taxes and was eventually shut down by court order after the government filed a suit. The funeral home closed its doors sometime between 2015 and 2017.

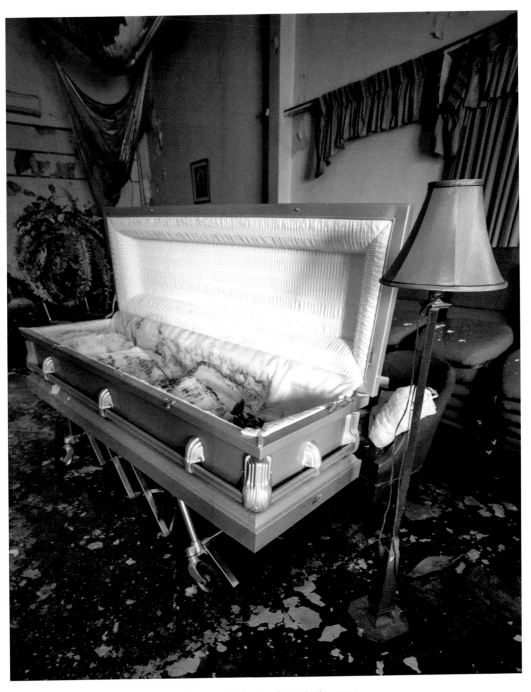

Damaged by rain and neglect, the roof leaks into the front viewing room.

9

POWER PLANTS

I t's hard to face the reality that coal-fired power, once so important in powering the state, has led to so many abandoned buildings throughout the region. Built between 1919 to 1925, this coal-fired generating plant was designed in a Neoclassical Revival style to reflect stability, performance, and dependability. The turbine hall was modeled after ancient Roman baths, with a curved skylight and massive open spaces. After sixty years of operation, the plant was closed and then used for Hollywood film sets for a period of time. Since then, the building has become a destination for many scrappers, who gather all they can year after year.

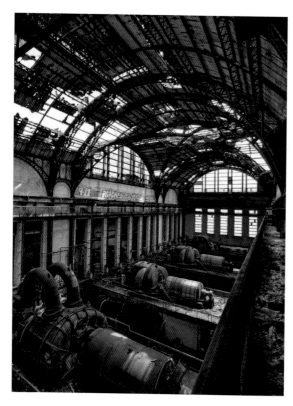

The view from the wraparound walkway above the turbine hall.

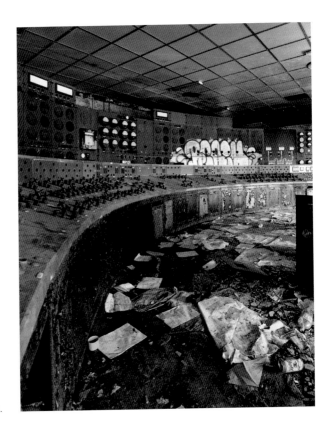

The floor of the control room is covered in old charts and paperwork.

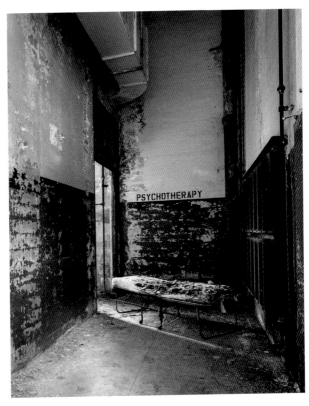

The remnants of a movie set.

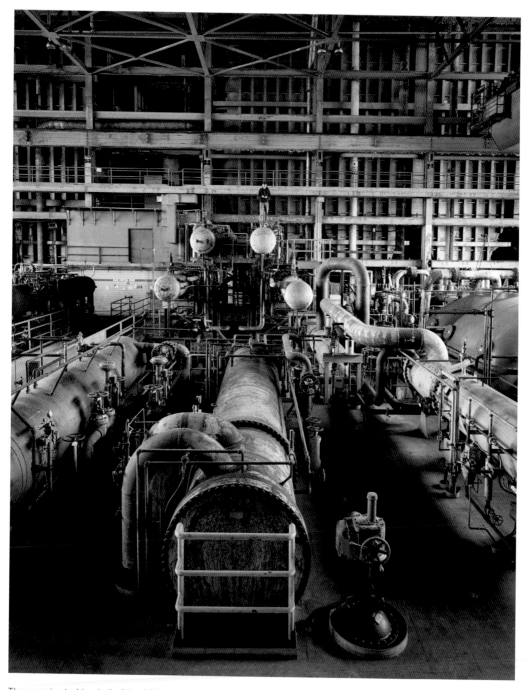

The massive turbine hall of the 1954 generating station. My traveling companion, Corey Gunz, stands on top, barely noticeable.

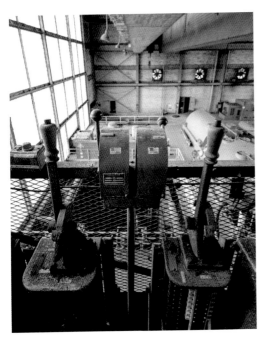

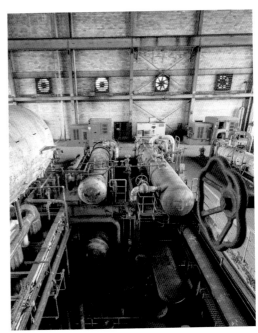

Above left: The crane's controls.

Above right: The pipes reflected in the flooded floors below.

Right: A small section of the plant's usually pitch-black control room.

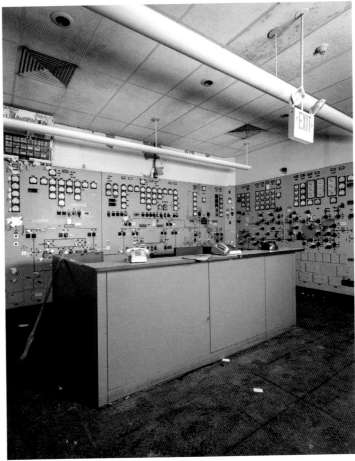

10

BANK VAULT

The Ninth National Bank, located in a once thriving textile district, has been neglected and decaying for decades. The bank opened in 1885 and printed money, totaling $2,883,150 of national currency, for thirty-nine years. Last active in 1983, the decaying bank was deemed too costly for restoration and slated for demolition. The ornate building's future now holds plans to redevelop the property, which includes the Industrial Title and Savings Trust Company.

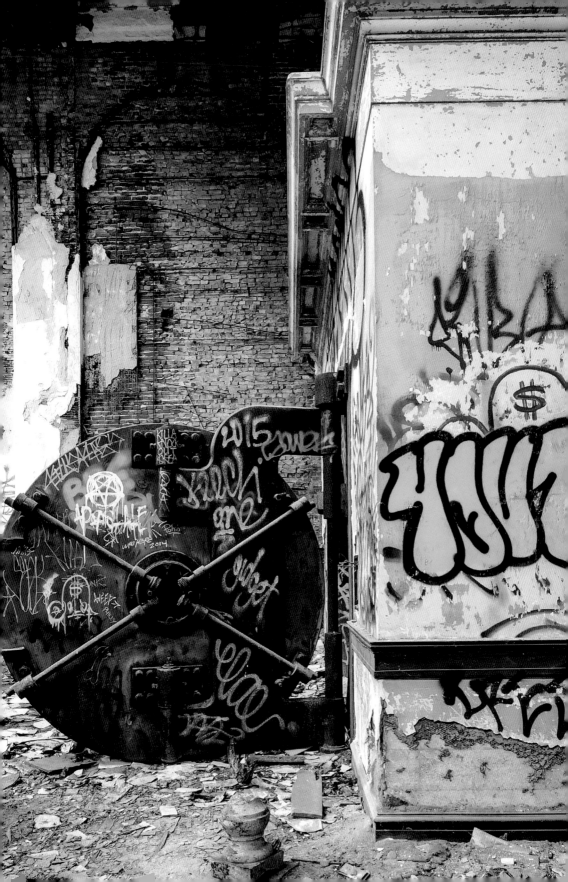

11

AMUSEMENT PARKS AND RESORTS

One might wonder how places that once brought families together can be so forgotten. The Poconos became a deeply familiar place for me, as the place we traveled for vacation from the time I was a small child. On our last family trip, my mother and aunt showed me the couples' resort where they once stayed with my father and uncle. I can imagine their joy and laughter, and it's hard to believe so many of the area's resorts are now abandoned. Those resorts—with their heart-shaped bars, tubs, and beds—were something out of this world. Pennsylvania has many other places of family fun that sadly have not withstood the test of time. Abandoned hotels, water parks, and amusement parks are scattered throughout the state.

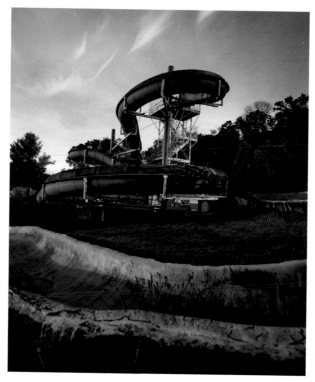

Opened in 1968, this small-town water park saw its final days in 2014.

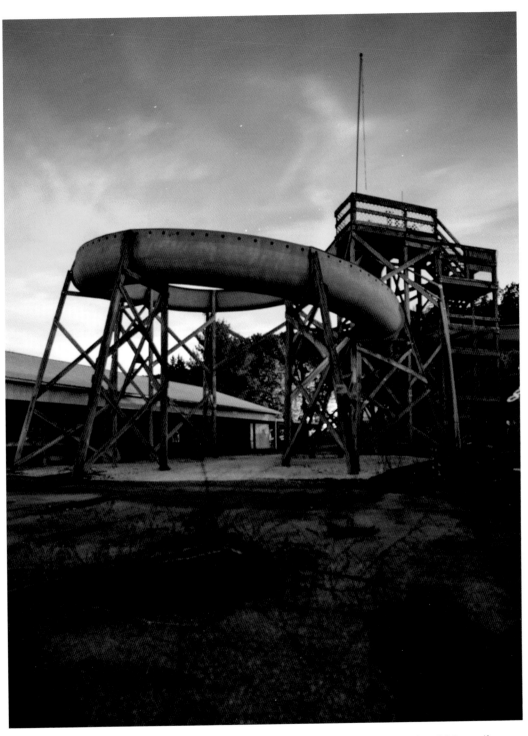

The water park consisted of a few water slides, a lazy river ride, a swimming pool, and a miniature golf course.

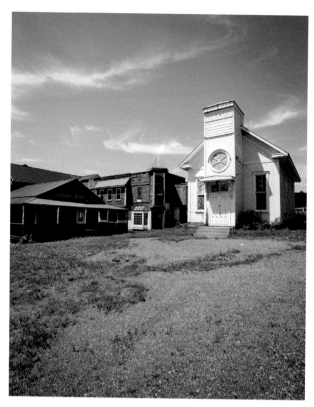

This recreation area, with its twenty-four historic buildings, sits alongside a highway. The property once held events for the public and catered to them with three restaurants, a bed and breakfast, a winery, and a general store.

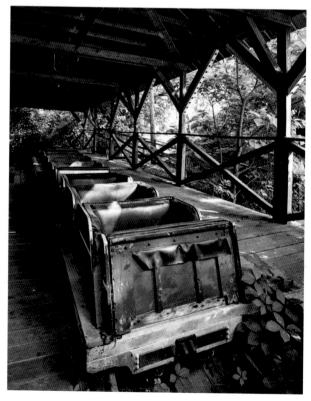

The Cyclone roller coaster, left rotting since 2005 when the amusement park closed.

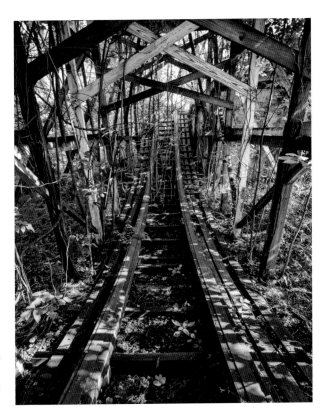

After the park flooded during a 2004 hurricane, the owners began a cleanup effort. But the funds ran dry shortly after. The park was in business for more than 150 years, but only the skeletons of a few rides are left, as the other attractions have been sold.

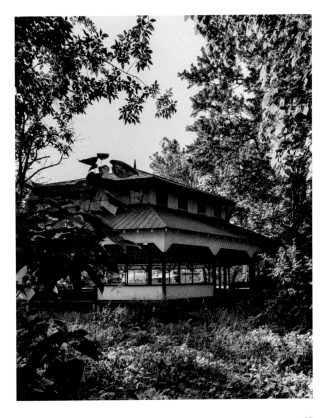

The park grounds remain, hiding beneath Mother Nature.

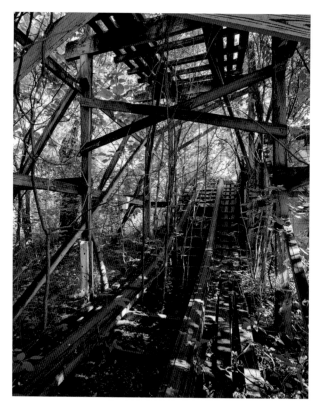

Vines wrap around the roller coaster beams.

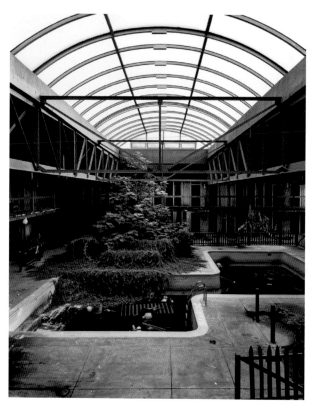

Nature is reclaiming the indoor swimming pool of this hotel, which closed in 2014. Throughout the building, the stench of black mold, a result of heavy rains and structural damage, pervades the building.

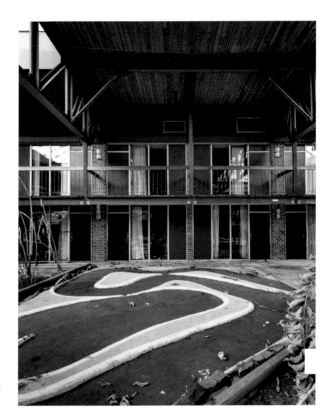

A miniature golf course located in the heart of the hotel.

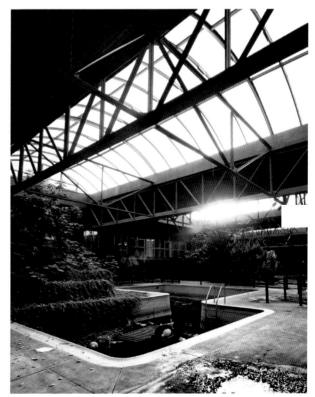

Once, guests in 145 of the hotel's rooms had a view onto the indoor swimming pool. The miniature golf course is located to the right of the pool. The sunlit center room also housed a tropical bar and a children's pool.

12

HOMES

Pennsylvania has a staggering number of abandoned homes, constructed from the 1700s to the modern day. Once filled with families, these houses are now vacant and forgotten. Many of the houses are strewn with personal belongings, and the same question always comes to mind: Why leave all behind and so suddenly? Some homes were inhabited by elderly, without or estranged form kin who could claim the property. Hoarders once occupied some of these houses, which are filled from floor to ceiling, making it hard to make your way around the home. Others are bare or have been stripped even down to the studs.

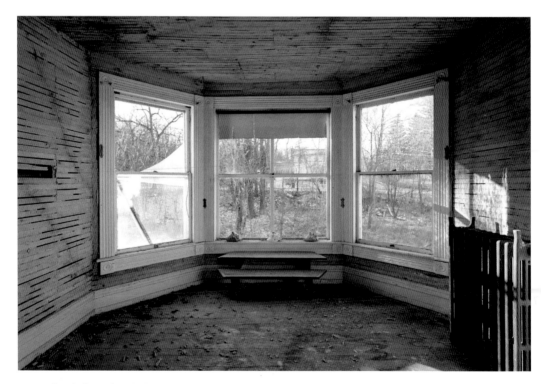

Seashells on the windowsill.

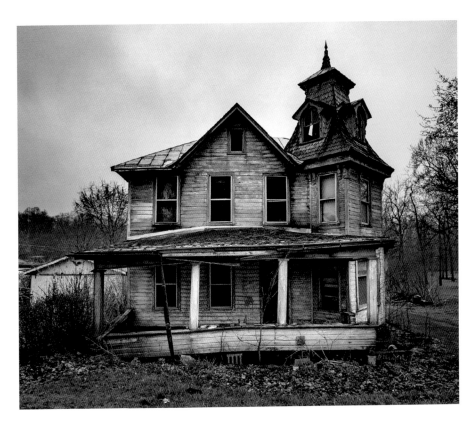

Above: Rainy days in a rural town. The owner lived to be 102 and was unable to sell her Victorian home because it fell victim being constructed in a flood prone area from the creek that runs alongside of it.

Right: I will forever cherish the time we had together and what you meant to me.

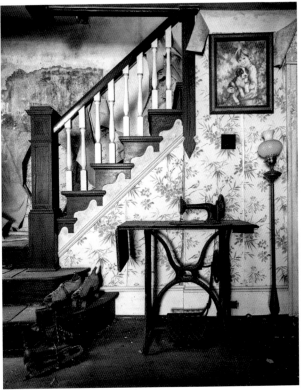

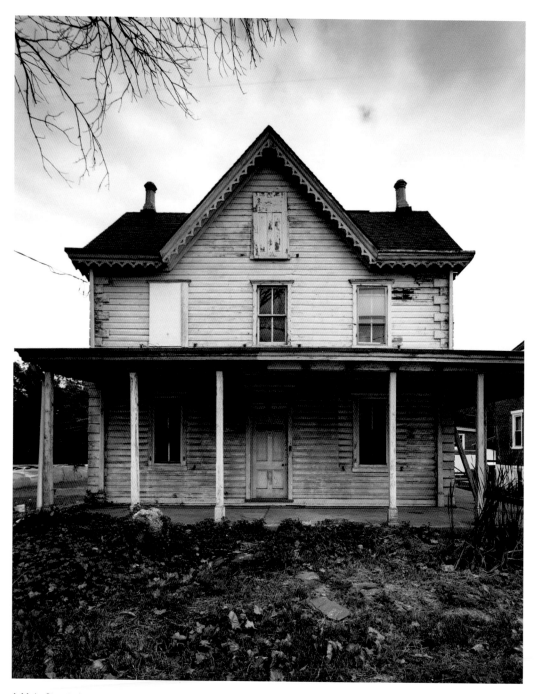

A Main Street charmer.

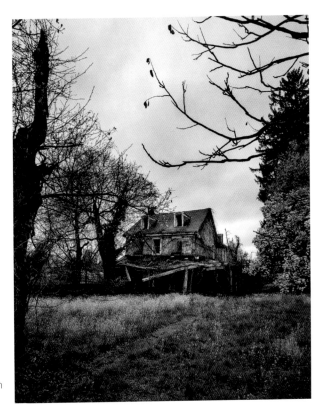

A mother and father goose perched on the porch roof, protecting their eggs.

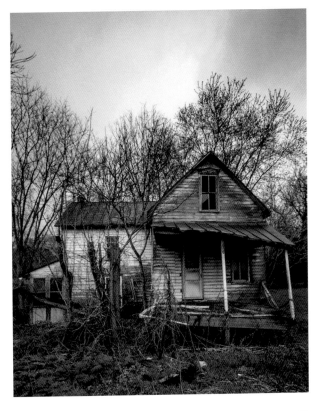

A tilting house on the side of a country road.

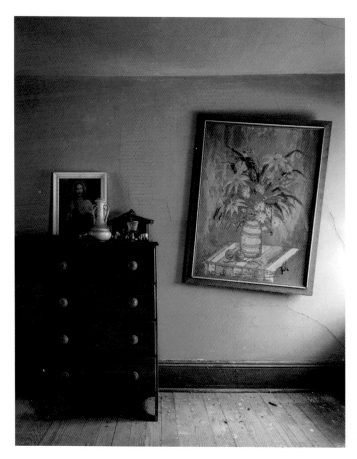

"Black Rock Farmhouse."

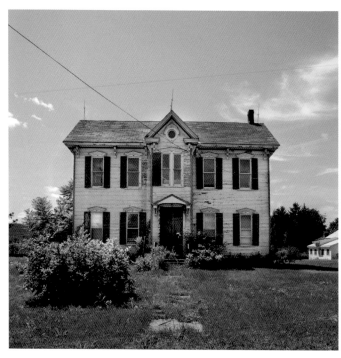

"Hoarders Storage House."

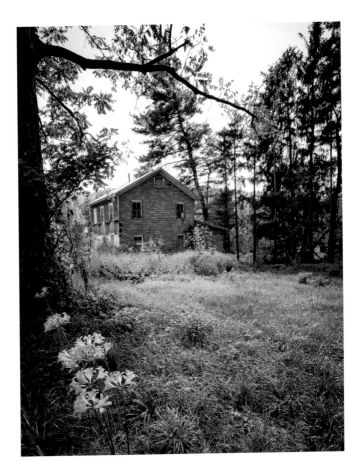

A lovely surprise on the journey home.

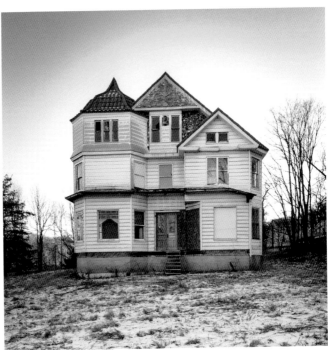

The sun slowly sets on the seashell-adorned house.

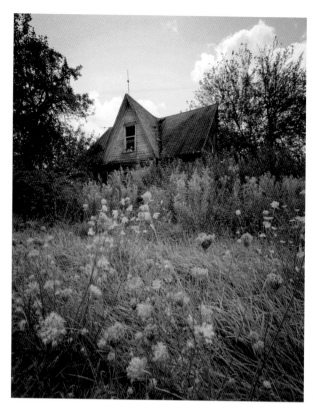

Even though you're weathered and worn, you are still beautiful.

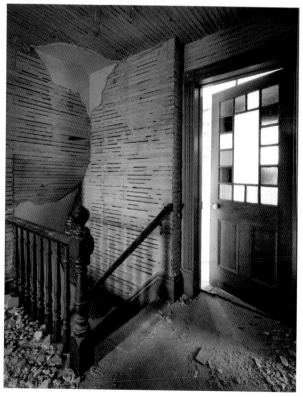

Light pours through the stained-glass bathroom door.

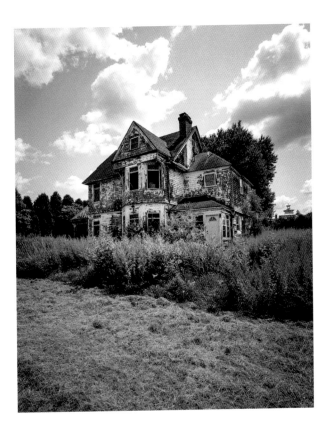

Beneath summer clouds.

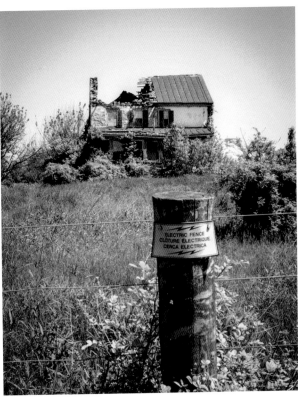

Beware of the electrical fence.

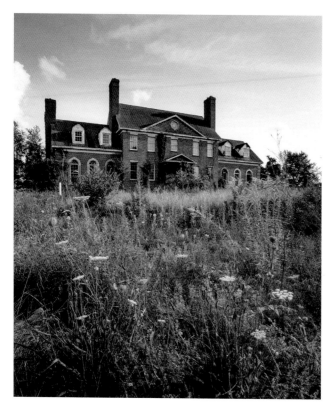

The driveway leading to the house can no longer be seen. The weeds have again claimed the ground as theirs.

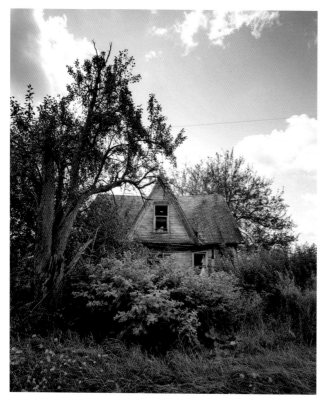

Across the street from this abandoned house, horse-drawn buggies came down the driveway of an Amish farm.

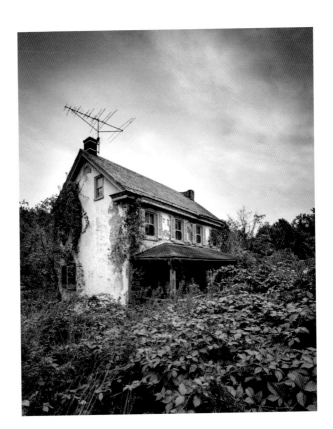

Protected by overgrown brambles
and thorns.

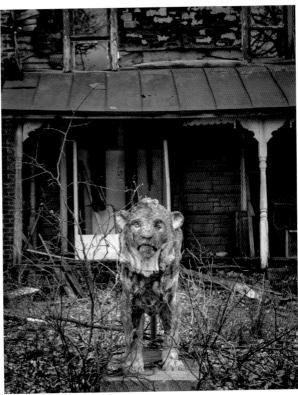

The protector of this dirt roadhouse.

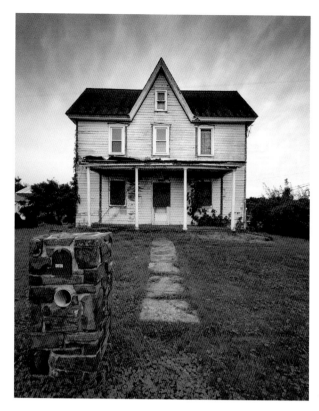

Ivy slowly climbs up this backroad farmhouse.

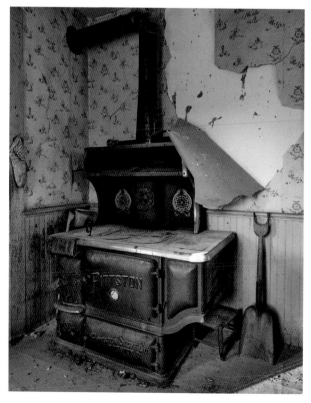

Oven mitts hang on the door frame and a shovel leans against the kitchen wall, as if they were meant to be used again.

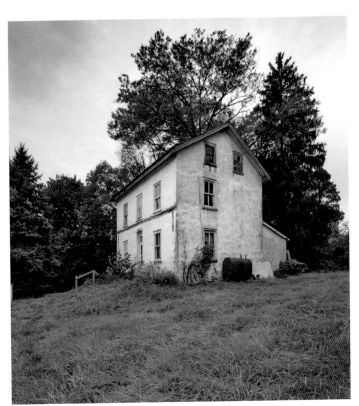

Tears seem to spill from the
windows beneath the gables.

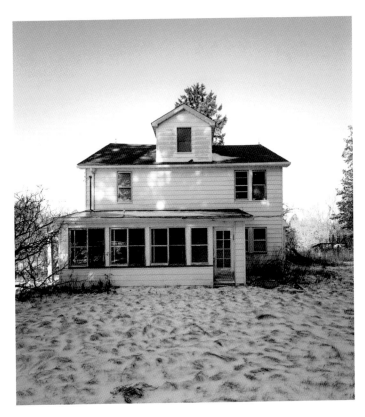

The sun falls low in the sky
on a bitterly cold day.

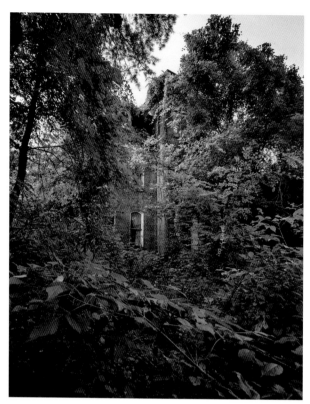

The summer months take over hiding the beauty of this 1800s Second Empire-style house with ivy and foliage. The house was occupied until the early 1980s and has been decaying ever since. The back of the house, from the original building constructed in the late 1700s, has collapsed. Stepping into this house was not the wisest decision. Sections of the floor give way, from years of water damage, as you walk on them.

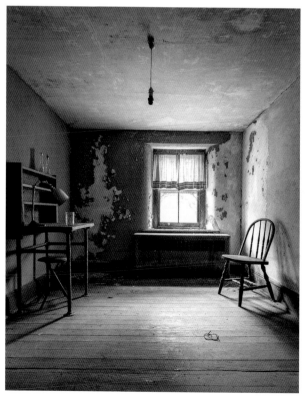

Summer sunlight illuminates the room.

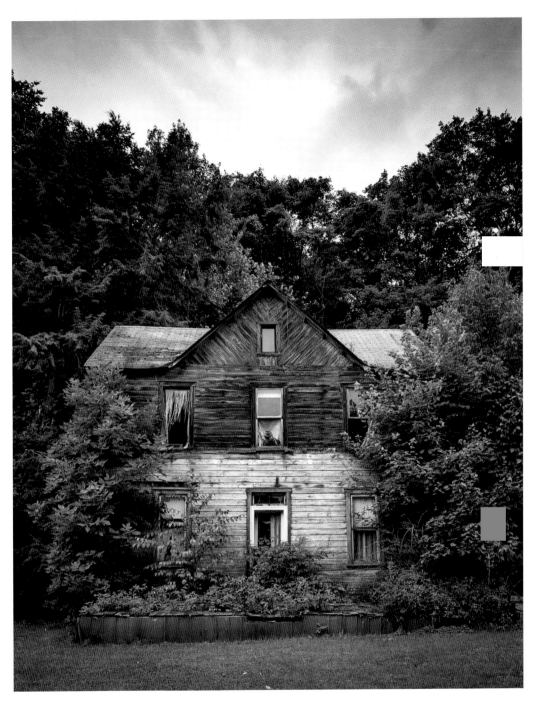

A rural farmhouse in the summer rain.

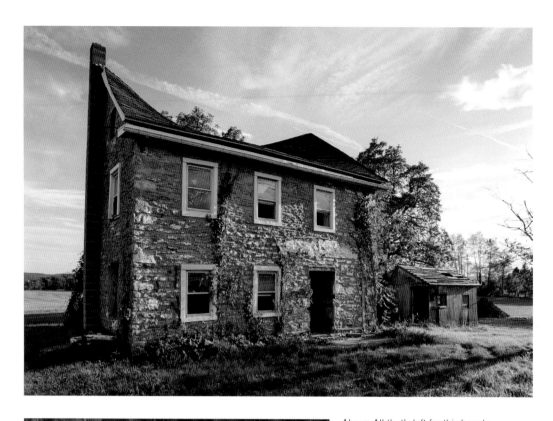

Above: All that's left for this beauty is time.

Left: Elegant decay.

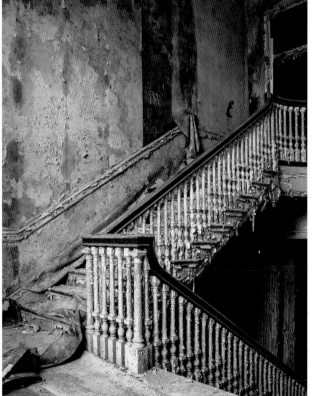

This 110-room Neoclassical Revival mansion was built between 1897 and 1900 for an American businessman and art collector. The $11 million estate contains fifty-five bedrooms, a large ballroom, a basement swimming pool, and upholstery and carpentry studios. A large portion of the estate grounds have been sold off, and the house has been largely vacant since 1952.

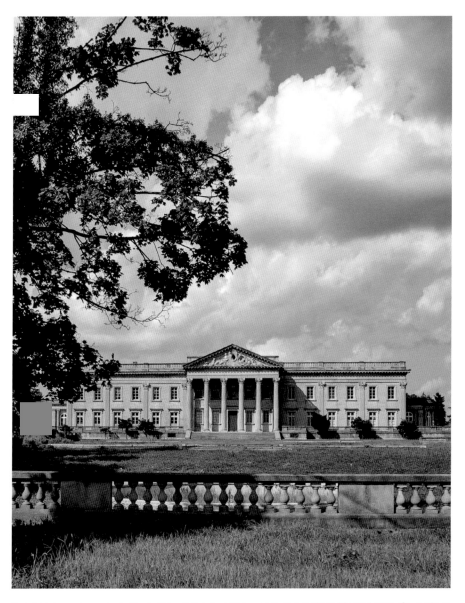

A guard dog now protects the inside of the mansion, which is popular with explorers. On a trip to photograph the exterior, I saw him barking in the second-floor window, warning us to stay out.

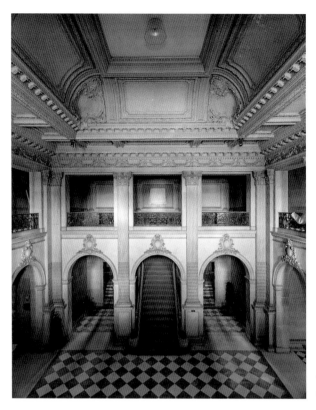

The view from the balcony overlooking
the main entrance.

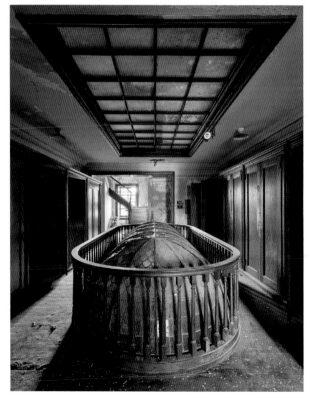

Skylights above skylights.

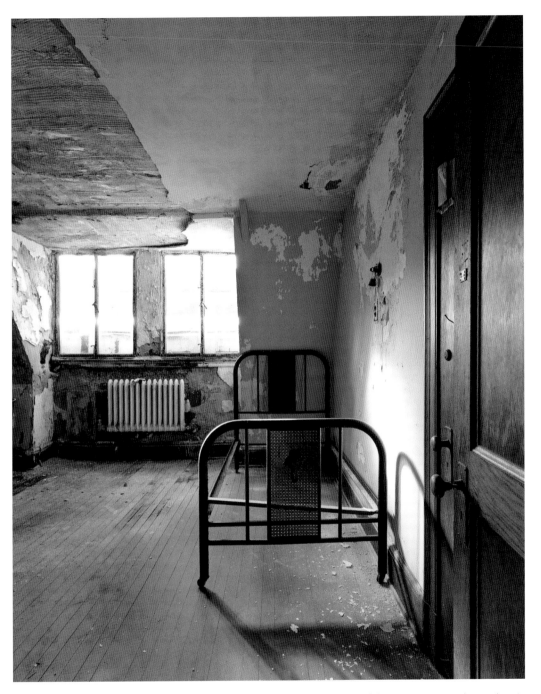

The mansion's top floor houses brightly colored bedrooms. I wondered if they were once used as a place to rest for visiting friends. Or perhaps they were the servant's quarters, as they lack the ornate details of the rest of the mansion.

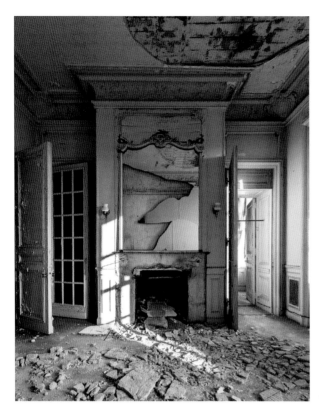

My heart breaks to see such a beauty
fall into ruin.

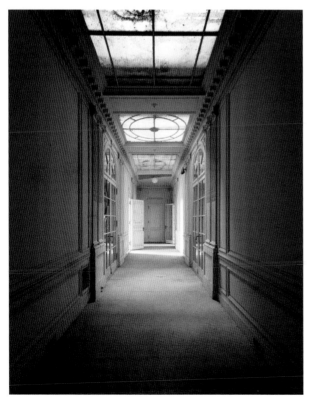

Intricate craftsmanship and fine
details are everywhere.

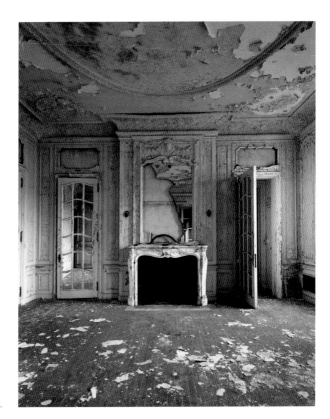

An ornate room with a built-in safe located to the right in the open closet.

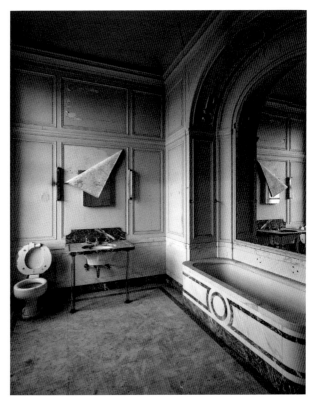

An elegant bathroom.

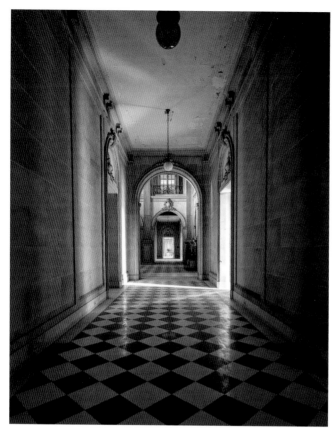

Left: Light pours out of the classroom, illuminating the ornamental details in one wing of the main floor.

Below: A bedroom filled with mirrors and charm.

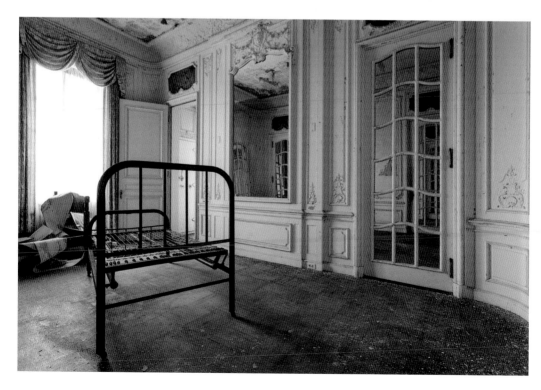

13

TRANSPORTATION

F orms of transportation long out of use can be spotted throughout the state: vintage cars, trains, and trolleys decaying over the years from exposure to the elements.

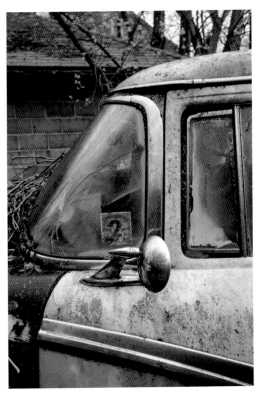 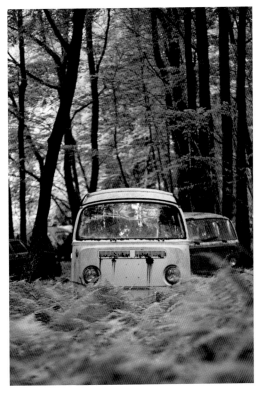

Above left: The registration expired in 1980. The car's blue color is still vibrant, even as it is covered more and more each passing year by mold and fallen branches.

Above right: Again, a Volkswagen bus in a country graveyard.

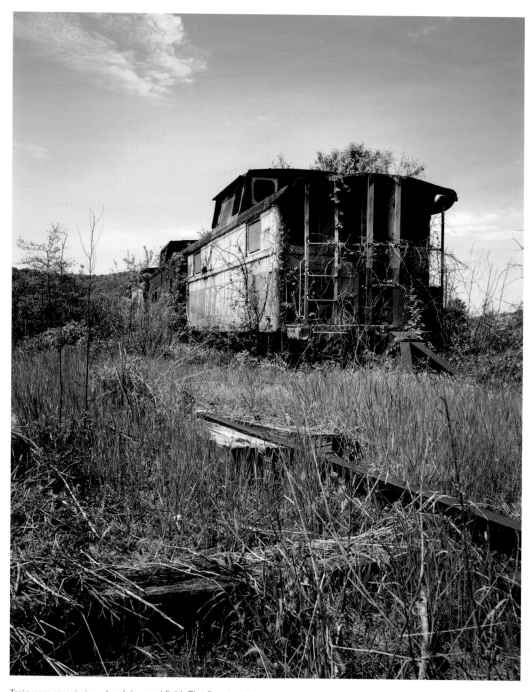

Train cars remain in a desolate, rural field. The Reading Company was involved in the southeast and neighboring states from 1924 until 1976.

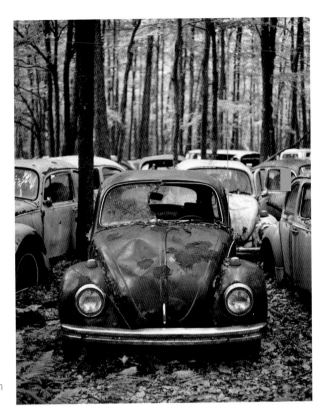

Punch buggies in a Volkswagen
junkyard.

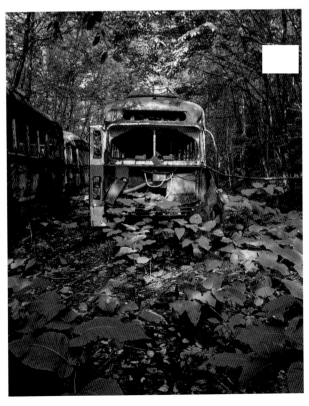

A trolley graveyard.

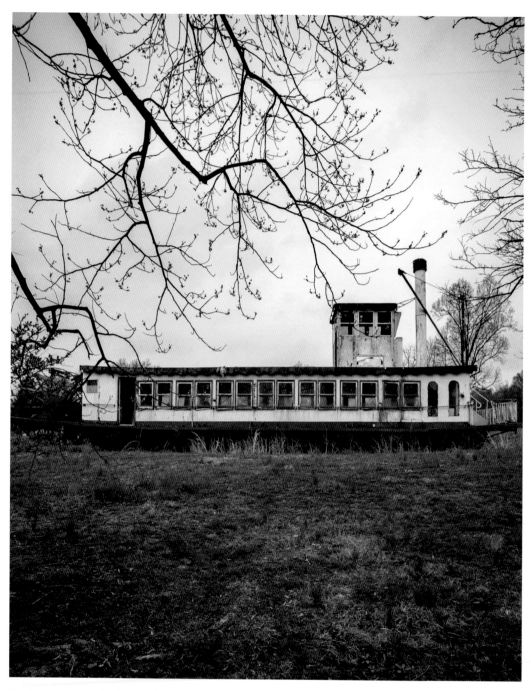

An abandoned, once floating riverboat saloon finds its way through an open field.

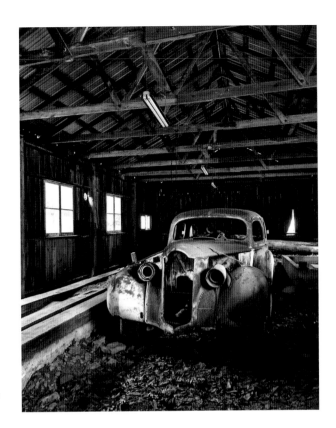

You never know what you'll come across in a barn, overgrown by trees and vines, on the back roads.

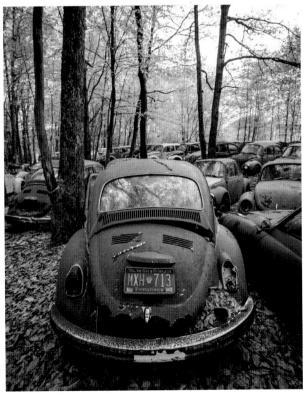

You've got a friend in Pennsylvania.

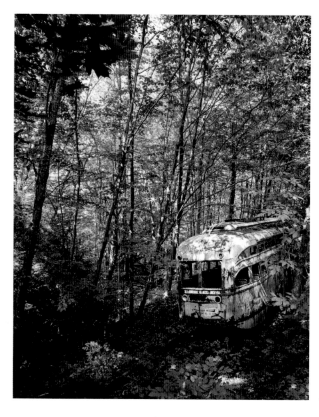

A trolley, climbing and hopping.

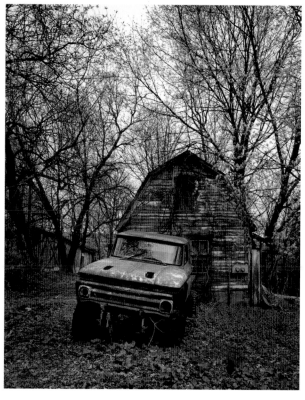

An abandoned farm spotted off the highway.